CATSKILL MOUNTAIN DRAWINGS

CATSKILL MOUNTAIN DRAWINGS

...

RICHARD M^CDANIEL

with Introduction by

Thomas E. Nelson

A PHANTOM PRESS BOOK
Woodstock, New York

• • •

Published By
PURPLE MOUNTAIN PRESS
Fleischmanns, New York

A Phantom Press
First Edition
1990
published by
Purple Mountain Press, Ltd.
Main Street, P.O. Box E-3
Fleischmanns, New York 12403

Copyright © 1990 by Richard McDaniel

All rights reserved. No part of this publication may be
reproduced or transmitted in any form or by any means
without permission in writing from the publisher
except by a reviewer who wishes to quote brief
passages in connection with a review written
for inclusion in a magazine, newspaper or
broadcast. For further information
address the publisher.

ISBN 0-935796-17-7

Printed in the United States of America

To Elizabeth

. . .in every walk with Nature, one receives far more than he seeks.

— John Muir

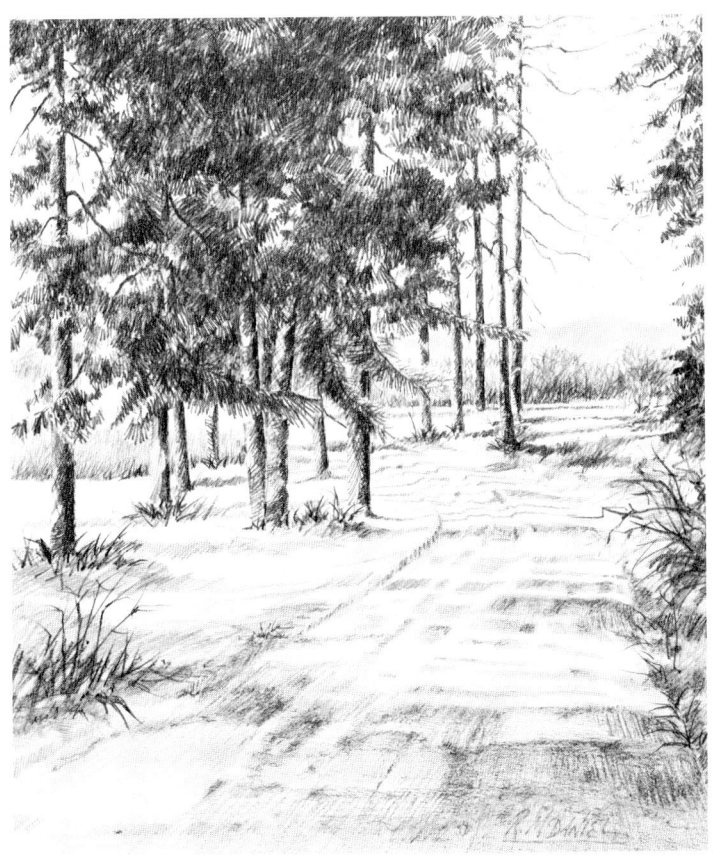

D8903 Greendale

Note

The origins of this book were modest. At the outset, no specific collection of drawings was planned, and no publishing deadline served as a guiding beacon. The Catskill drawings evolved naturally, slowly, over the past decade. It was only after these seemingly unrelated images began to accumulate that I recognized them as a potential series.

A book of drawings was first suggested to me by Robert Angeloch, President of the Woodstock School of Art. Originally conceived as a brief pictorial survey of the artwork, the project grew in scope as my interest gained momentum. Soon, other tasks were set aside as I concentrated my energies upon the drawings and writing for this volume. Such a concentration would have been more difficult if not for the understanding and encouragement of several people.

Foremost on the list is my family, whose patience with me deserves a mountain of praise. I would like to thank Thomas E. Nelson of the Albany Institute of History and Art for taking the

time and interest to write such a laudatory introduction. I am grateful to Robert Angeloch; not only is he a worthy croquet partner, but a wellspring of valuable advice. Also my thanks to Wray and Loni Rominger at Purple Mountain Press for their faith and astute technical advice. Finally, a word of appreciation to friends and students for both challenging and supporting my developing ideas.

<div align="right">RWMcD</div>

Contents

List of Quotations	15
List of Drawings	16
Introduction	21
Catskill Mountain Drawings	
Text	27
Drawings	42

Quotations

Author	Page
WILLIAM CULLEN BRYANT (1794-1878)	70
JOHN BURROUGHS (1837-1921)	41, 46, 52, 57, 69, 79, 96, 102, 106
JOHN F. CARLSON (1874-1945)	44
THOMAS COLE	65, 72, 85, 93
JAMES FENIMORE COOPER (1789-1851)	19, 49, 67, 76
RALPH WALDO EMERSON (1803-1882)	63, 91, 108
WASHINGTON IRVING (1783-1859)	27, 82
JOHN MUIR (1838-1914)	8, 76
ELEANORE ROOSEVELT (1884-1962)	42
HENRY DAVID THOREAU (1817-1862)	50, 58, 88, 99, 100, 104
WALT WHITMAN (1819-1892)	61

Drawings

Number		Size	Medium	Page
D8203	Byrdcliffe Summer	9 x 11	Pencil	42
D8205	The Hudson & The Catskills	9 x 11	Pencil	72
D8303	Of Course, Woodstock	14 x 16	Pencil	87
D8304	Rough Edge, Woodstock	14 x 16	Pencil	86
D8307	Overlook Trail	8 x 10	Pencil	45
D8401	Overlook From The Fifth Green	9 x 11	Pencil	84
D8403	Looking West, Toward The Catskills	9 x 14	Pencil	71
D8405	Shore Line, North Lake	8 x 11	Pencil	75
D8406	Southwest From The Ashokan	8 x 11	Pencil	74
D8409	Winter Stream & Hemlocks	9 x 10	Charcoal	61
D8501	Sap Run	14 x 11	Pencil	56
D8502	Sap Run	8 x 12	Pencil	57
D8505	Catskill Pond	13 x 20	Pencil	91
D8506	Schoharie	13 x 20	Pencil	90
D8509	Woodland Valley	14 x 11	Charcoal	68
D8601	Gray Rocks On Wooded Slope	9 x 7	Pencil	59
D8602	Fawns Leap, Wildcat Ravine	20 x 16	Pencil	81
D8603	Bare Roots, Kaaterskill Clove	11 x 9	Charcoal	60
D8604	Woodland Interior, Mink Hollow	14 x 11	Charcoal	62
D8606	The Ashokan From The Wittenberg	11 x 9	Charcoal	78
D8701	The Catskills From Greenport	9 x 7	Pencil	83
D8702	Leeds Bridge Over Catskill Creek	9 x 11	Pencil	55
D8705	Falls Along The Sawkill	14 x 20	Pencil	58
D8706	Slide Mountain Trail	20 x 14	Pencil	64
D8707	Slide Mountain Summit	6 x 12	Pencil	77
D8708	Kaaterskill Falls	19 x 14	Pencil	66
D8709	Bridge Over The Sawkill	11 x 14	Pencil	80

The mountains, the streams, and the nearby meadows offer ample opportunities for painting excursions with my landscape classes. It is often here that I outline theories on composition, and what attracts me to certain subjects.

From my years working as an abstractionist painter I have developed a love of structure, and a love for the interrelationship between shapes, colors, and textures. This is fundamental to my thinking process. I regard the importance of composition, irrespective of style, to be universal. Today my work centers upon an abstract substructure, with landscape imagery serving as the theme.

There are times when I choose to draw or paint a scene with familiar views. The mountain peaks can be named, one by one, or the river passes beneath an easily recognized bridge. However, these motifs are not chosen for their identifiable traits, but rather for their compositional merit.

Structure may be found in any scene, regardless of its fame, or lack of it. If an aesthetic tension exists between, for example, a near-vertical tree trunk and a diagonal shadow, a compelling design can readily be developed. Furthermore, the placement

of these elements upon the page is equally important. *Where* an activity occurs has as much relevance as the activity itself. Compositional arranging, or formatting, can make a dynamic drawing out of the most ordinary of subjects. It is this underlying framework that I find particularly appealing in both creating and viewing artwork.

I frequently redraw the components of a preliminary sketch upon another piece of paper, forcing a horizontal composition into a vertical format, or vice versa. Often this analysis reveals new meaning, and displays a dialogue between opposing masses and planes. The interplay of various elements, contrasting and supporting, produces the dynamic tension of a promising drawing.

When the challenges of composition are satisfied, the mind is free to concentrate fully upon the emotional content of an artwork. Strength comes from structure, but it needs feeling to make it whole. The expressive content of any work of art is central to its purpose. Artists must have something to say: they must spiritually connect with their subjects. In the words of Vincent van Gogh, "I see

in nature, for example, in trees, expression and, as it were, a soul." This feeling for the subject, regardless of style, balances form with content, and breathes life into the work.

• • •

Most of the drawings reproduced in this book were completed with a handful of yellow, garden-variety, no. 2 pencils. I find them to be a wonderful yet inexpensive tool. To maintain clean lines, the trick is to keep the points sharp. Since soft pencils tend to dull quickly, it is wise to sharpen several at once. This prevents the interruption of creative flow for sharpening. Also, it lessens the temptation to continue using a pencil whose point is no longer crisp. It can make a remarkable difference.

For broad passages of soft tone I adopted the technique of "dry wash." This method involves generously scribbling on a scrap piece of paper with a soft pencil, then rubbing a tissue into the graphite smudge. Next, the darkened tissue is gently rubbed into the drawing, transferring a delicate

shade. Repeated applications or feathering with an eraser will produce a wide range of results.

A few additional pencils, either harder or softer, were used for lighter or darker sections. Charcoal and the ubiquitous kneaded eraser round out the list of supplies, except for the papers.

Many inspired drawings have been executed with a borrowed ballpoint pen on a cocktail napkin or the back of an envelope. What they gained in spontaneity, however, they lost in their lack of permanence. I have come to employ a variety of papers for a variety of reasons, but for the majority of these Catskill drawings I utilized small panels of museum board. These are the center scraps of 100%-rag mat board, a material which is chemically stable and offers a surface texture which suits my needs. It is soft enough to permit deep rich darks, yet hard and smooth enough to allow some erasure and manipulation of lines.

Museum board presents another great advantage for the outdoor draftsman — its rigidness is unaffected by wind, and the boards require no extra support. Not only is this material of high quality, it is convenient.

The subject matter of the drawings can be divided into three interrelated categories. In some compositions a specific group of mountains, or a conspicuous landmark dominates, and is, within reason, topographically accurate. These images remain interesting to me for their distinctive shapes, whether they can be named or not. Sometimes, however, interest is heightened by the very fact that specific sites have specific histories.

Other drawings were inspired by many of the same emotional sensations: the inherent design of the motif captured my attention. But these scenes were not selected for their recognizability whatsoever. The drawings are my responses to anonymous organic shapes and rhythms. To the viewer they may suggest a sunlit walk, a windy day, or nothing at all. To me they represent a profound empathy for nature, and its unlimited potential for implicit compositions.

The third type of drawing included in this edition springs from the above-mentioned empathy, but reaches deeper into the structural essence of the motif. They are often studies of ordinary weeds, rocks, and branches. A natural abstraction emer-

ges from this examination of fragments, and of their immediate space. Drawings of this sort have undergone a process whereby qualities of the subject have been absorbed, digested, and filtered through the alembic of my own personal vision.

• • •

I did not pass my childhood in the shadow of these mountains, nor did I know the pride in them shared by local inhabitants. Though my objective viewpoint was at first unencumbered by regional knowledge, I soon discovered there were many who had come before me and had been equally inspired by the Catskill experience.

I have included several brief quotations by Burroughs, Muir, Thoreau, and others, for their words seem to be in harmony with my own observations. The drawings are not illustrations of these written passages, nor are the quotations responses to my drawings. They are grouped together on these pages as companions, for each is a separate response to the same stimulus: Nature.

With this book of drawings I am sharing my deep affection for the landscape of the Catskill region. A walk in the woods frequently serves as a tonic, restoring spirits and reaffirming the magnitude of Nature's influence. Walking in the Catskills, I feel a closeness with that influence, and a relaxed peace within. I feel at home.

. . .when I go to the woods or fields or ascend to the hilltop, I do not seem to be gazing upon beauty at all, but to be breathing it like the air. . .I am not a spectator of, but a participator in it.

—John Burroughs

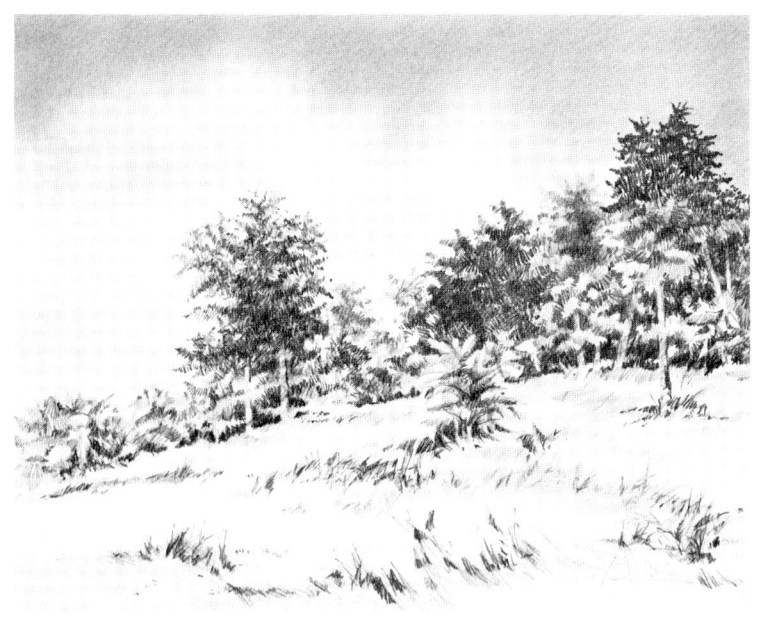

D8203 Byrdcliffe Summer

I have always loved the Catskill Mountains, and at Woodstock they loom very near at hand. In every direction there seemed to be attractive spots to paint.

— Eleanore Roosevelt

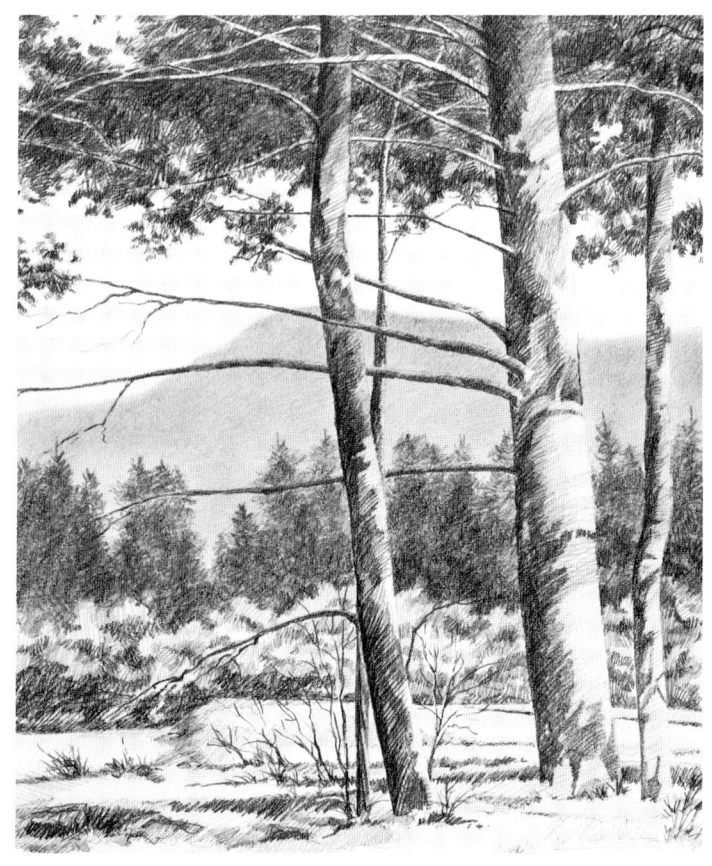

D8901 Woodstock Winter

To the artist the forest is an asylum of peace, of dancing shadows, of sun-flecked green.

—John F. Carlson

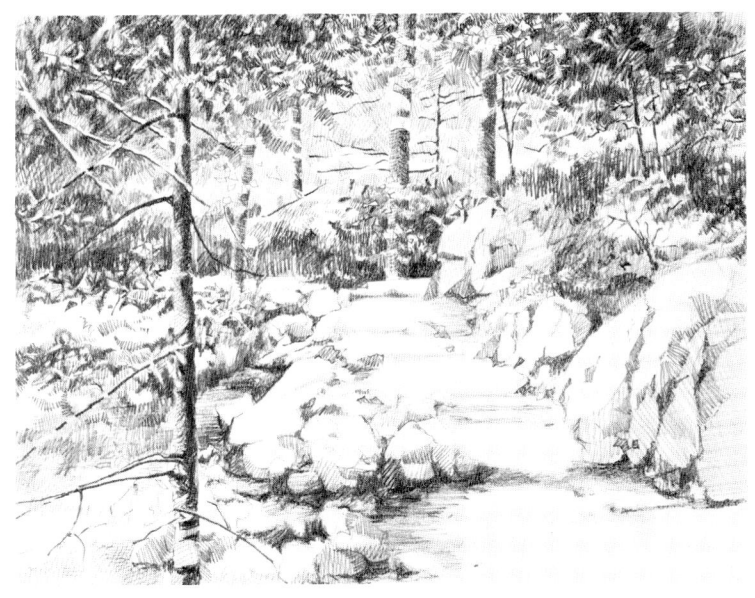

D8307 Overlook Trail

One's own landscape comes in time to be a sort of outlying part of himself; he has sowed himself broadcast upon it, and it reflects his moods and feelings....

—John Burroughs

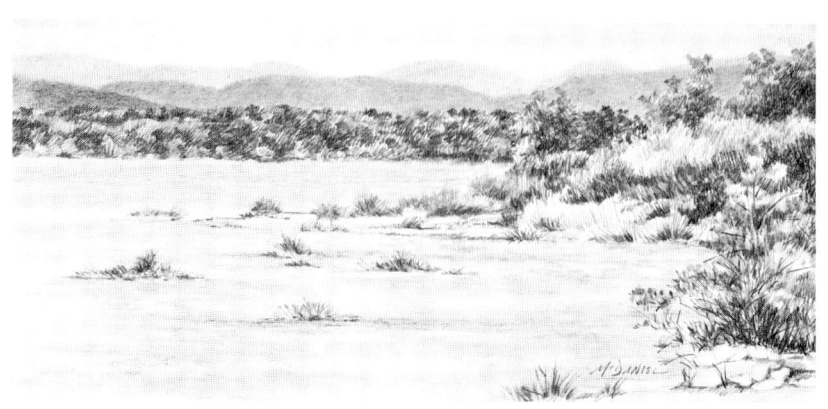

D8912 Ashokan, To The North

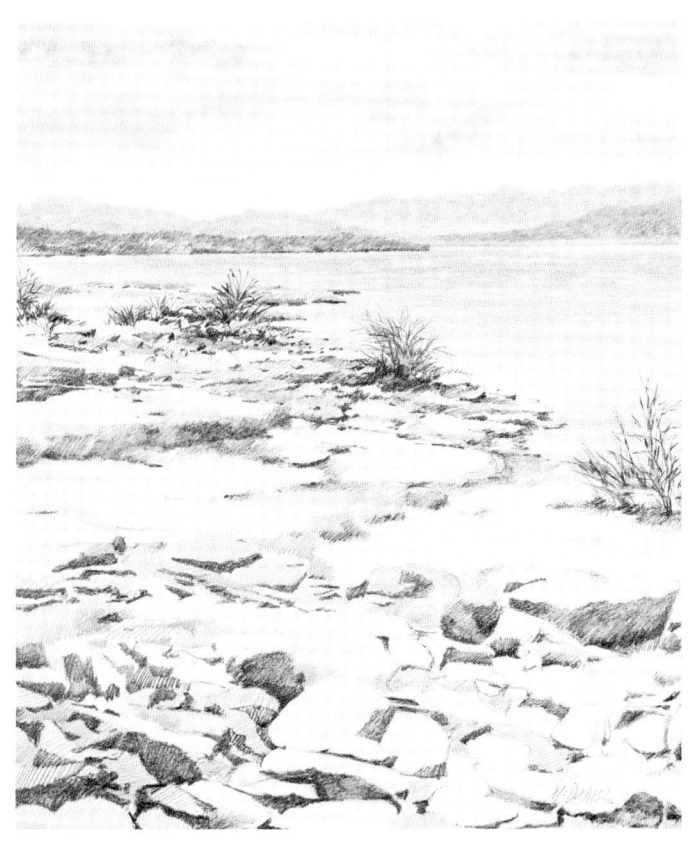

D8811 Ashokan, To The West

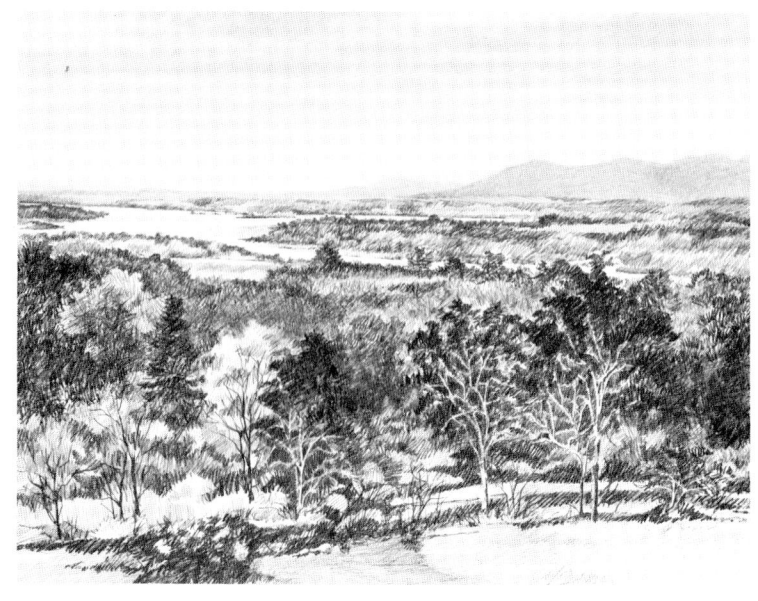

D8809 The Hudson & The Catskills From Olana

It is a spot to make a man solemnize. You can see right down into the valley...where thousands of acres of woods are afore your eyes....

—James Fenimore Cooper

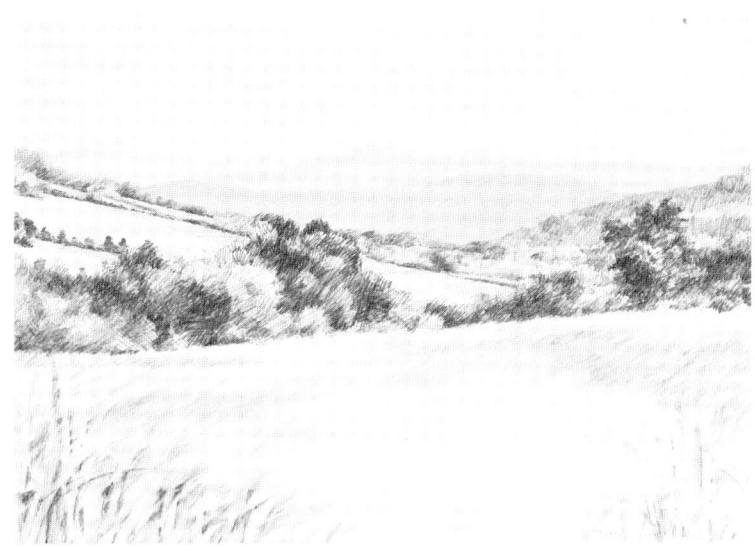

D9013 Western Catskills

The landscape looked singularly clean and pure and dry, the air, like a pure glass, being laid over the picture, the trees so tidy, and stripped of their leaves; the meadows and pastures, clothed with clean dry grass, looked as if they had been swept; ice on the water and winter in the air, but yet not a particle of snow on the ground.

— Henry David Thoreau

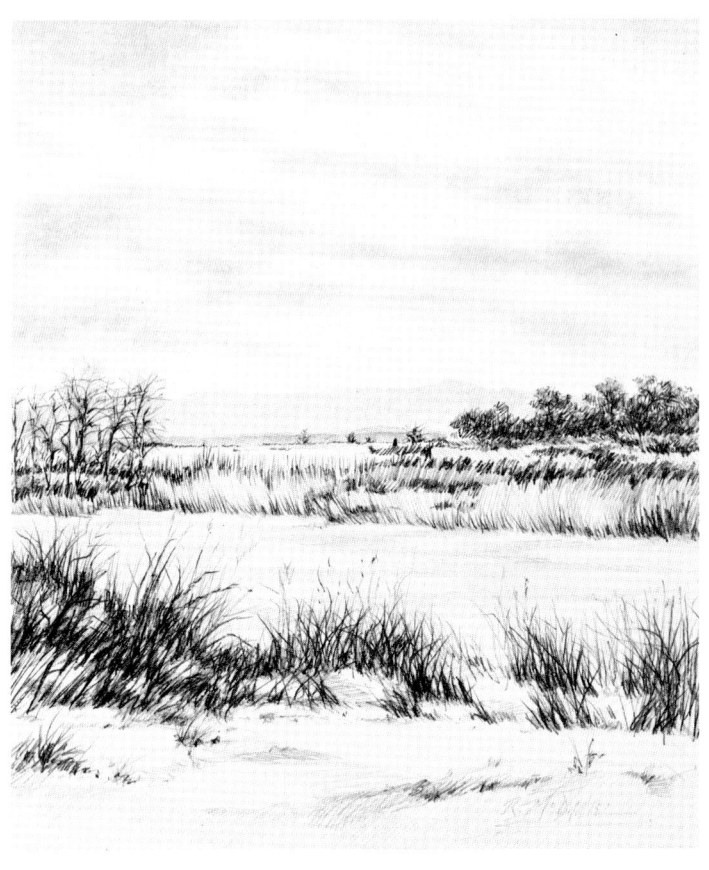

D8814 Frozen Pond Near Olana

He who marvels at the beauty of the world in summer will find equal cause for wonder and admiration in winter.

—John Burroughs

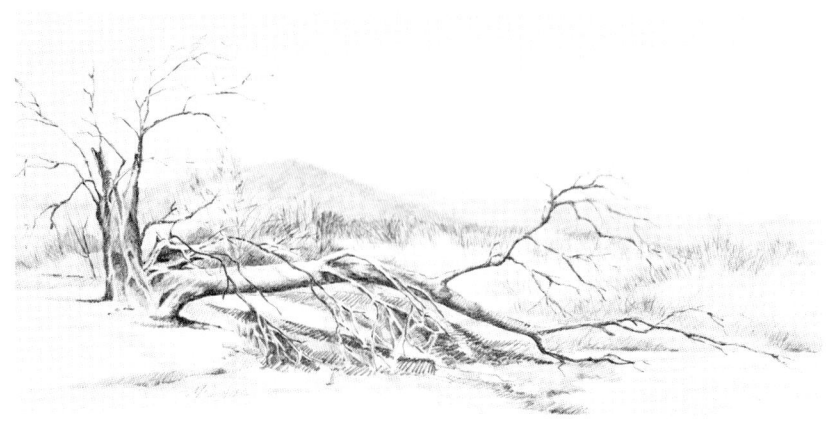

D8802 Broken Willow, View of High Point

D8801 Hurley Flats In Winter

D8906 Catskill Winter Hills

D8702 Leeds Bridge Over Catskill Creek

D8501 Sap Run

It is. . .the distilled essence of the tree.
— John Burroughs

D8502　Sap Run

It seems natural that rocks which have lain under the heavens so long should be gray, as it were an intermediate color between the heavens and the earth.

— Henry David Thoreau

D8705 Falls Along The Sawkill

D8601 Gray Rocks On Wooded Slope

D8603 Bare Roots, Kaaterskill Clove

I never saw finer or more copious hemlocks... A primitive forest, druidical, solitary and savage....

— Walt Whitman

D8409 Winter Stream & Hemlocks

D8604 Woodland Interior, Mink Hollow

The tempered light of the woods is like a perpetual morning, and is stimulating and heroic. The anciently reported spells of these places creep on us. The stems of pines, hemlocks, and oaks, almost gleam like iron on the excited eye. The incommunicable trees begin to persuade us to live with them, and quit our life of solemn trifles.

— Ralph Waldo Emerson

D8706 Slide Mountain Trail

In the American forest we find trees in every stage of growth and decay — the slender sapling rises in the shadow of the lofty tree, and the giant in his prime stands by the hoary patriarch of the wood — on the ground lie prostrate decaying ranks that once moved their verdant heads in the sun and wind.

— Thomas Cole

D8911 Fallen Tree

D8708 Kaaterskill Falls

Why, there's a fall in the hills, where water of two little ponds that lie near each other breaks out of their bounds, and runs over the rocks into the valley... The first pitch is nigh two hundred feet, and the water looks like flakes of driven snow, afore it touches the bottom; and there the stream gathers together again for a new start, and maybe flutters over fifty feet of flat-rock, before it falls for another hundred, when it jumps about from shelf to shelf, first turning this-away and then turning that-away, striving to get out of the hollow, till it finally comes to the plain.

—James Fenimore Cooper

D8509 Woodland Valley

D8905 Maple Slope

Of all the retreats I have found among the Catskills there is no other that possesses quite so many charms for me as this valley. It is so wild, so quiet, and has such superb mountain views.

— John Burroughs

*Go forth, under the open sky, and list to
Nature's teachings, while from all around —
Earth and her waters, and the depths of air —
Comes a still voice.*

— William Cullen Bryant

D8403 Looking West, Toward The Catskills

Friends of my heart, lovers of Nature's works,
Let me transport you to those wild blue mountains
That rear their summits near the Hudson's wave.
Though not the loftiest that begirt the land,
They yet sublimely rise, and on their heights
Your souls may have a sweet foretaste of heaven,
And traverse wide the boundless.

— Thomas Cole

D8205 The Hudson & The Catskills

D8914 The Hudson & The Catskills From Tivoli Marsh

D8406 Southwest From The Ashokan

D8405 Shore Line, North Lake

The view from the summit could hardly be surpassed in sublimity and grandeur....
— John Muir

You can see all creation... The river is in sight for seventy miles, looking like a curled shaving under your feet....
— James Fenimore Cooper

D8707 Slide Mountain Summit

D8810 The Hudson From The Escarpment Trail

D8606 The Ashokan From The Wittenberg

You are here on the eastern brink of the southern Catskills, and the earth falls away at your feet and curves down through an immence stretch of forest till it joins the plain of Shokan, and thence sweeps away to the Hudson and beyond.

—John Burroughs

On the sound of flowing water:

Ah, if I could put into words that music which I hear; that music which can bring tears to the eyes of marble statues!

— Henry David Thoreau

D8709 Bridge Over The Sawkill

D8602 Fawns Leap, Wildcat Ravine

Of all the scenery of the Hudson, the Kaatskill Mountains had the most witching effect on my boyish imagination. Never shall I forget the effect upon me of the first view of them predominating over a wide extent of country, part wild, woody, and rugged; part softened away into all the graces of cultivation.

— Washington Irving

D9014 The Catskills From Mohonk Ridge

D8701 The Catskills From Greenport

D8401 Overlook From The Fifth Green

Around the mountains forest-crowned and green,
 Majestic rise,
Above, like love's triumphal arch, are seen
 The quiet skies.
How spread the waters like a crystal sea
 When breezes die,
And in their lucent depths cloud, hill and tree
 Reflected lie!

 — Thomas Cole

D8304 Rough Edge, Woodstock

D8303 Of Course, Woodstock

These earliest spring days are peculiarly pleasant. We shall have no more of them for a year. I am apt to forget that we may have raw and blustering days a month hence. The combination of this delicious air, which you do not want to be warmer or softer, with the presence of ice and snow, you sitting on the bare russet portions, the south hillsides, of the earth, this is the charm of these days. It is the summer beginning to show itself like an old friend in the midst of winter.

— Henry David Thoreau

D8904 The Catskills From Wiltwyck

D8506 Schoharie

D8505 Catskill Pond

He who knows the most, he who knows what sweets and virtues are in the ground, the waters, the plants, the heavens, and how to come to these enchantments, is the rich and royal man.

— Ralph Waldo Emerson

D8813　November

My attention has often been attracted by the appearance of action and expression of surrounding objects, especially trees. They spring from some resemblance to the human form. There is an expression of affection in intertwining branches....

— Thomas Cole

D8909 Pines

D8910 Pines

It is our partial isolation from Nature that is dangerous; throw yourself unreservedly upon her and she rarely betrays you.

— John Burroughs

D8807 February

D9003 Spring Saplings

When the ground was partially bare of snow, and a few warm days had dried its surface somewhat, it was pleasant to compare the first tender signs of the infant year just peeping forth....

— Henry David Thoreau

D9002 Creekside

I get away a mile or two from the town into the stillness and solitude of nature, with rocks, trees, weeds, snow about me. I enter some glade in the woods, perchance, where a few weeds and dry leaves alone lift themselves above the surface of the snow, and it is as if I had come to an open window. I see out and around myself.

— Henry David Thoreau

D9004 Wild Grasses

D9007 March Weeds, Ice

> *Nature is always new in the spring, and lucky are we if it finds us new also.*
>
> —John Burroughs

D9008 March Weeds, Treetrunk

Each new year is a surprise to us. We find that we had virtually forgotten the note of each bird, and when we hear it again it is remembered like a dream, reminding us of a previous state of existence. How happens it that the associations it awakens are always pleasing, never saddening; reminiscences of our sanest hours? The voice of nature is always encouraging.

— Henry David Thoreau

D9010 Matted Straw

D8916 Wild Grapes

. . .the student and lover of nature has this advantage over people who gad up and down the world seeking some novelty or excitement: he has only to stay at home and see the procession pass.

—John Burroughs

D8915 Wild Grapes

Phantom Press Publications

1965	MONHEGAN – 23 Drawings by Robert Angeloch
1966	DRAWINGS OF WOODSTOCK – Drawings by Lon Clark, Richard Crist, Jacques Kupferman, Robert Angeloch
1966	RILLET – 23 Drawings by Robert Angeloch
1967	WOMAN – Paintings and Text by Lynfield Ott
1974	LAMBS OF THE CATSKILLS – Poems and drawings by Jean Wrolsen
1974	LAND IN THE SKY – Poems by Anne Fessenden, Drawings by Robert Angeloch
1977	INNERSCAPES – Drawings and Text by Michael Esposito
1978	THE SAWKILL AT ZENA – Drawings by Robert Angeloch with Text by Dennis Drogseth
1980	*ANGELOCH: COLOR SERIGRAPHS – Text and Poetry by Carole Van Chieri with Introduction by Lawrence Campbell
1980	ROSELLA HARTMAN – Lithographs 1923-1959 with Introduction by Dennis Drogseth
1981	WOODWEAVE – Drawings and Verses by Jean Wrolsen
1986	ISLAND POSSESSION – Verses by Jean Wrolsen, Etchings by Robert Angeloch
1988	*ROBERT ANGELOCH: EARLY PRINTS – Woodcuts, Etchings, and Lithographs 1947-1966 with Introduction by Liam Nelson
1988	ROBERT ANGELOCH: Paintings and Prints of Wales
1988	*ROBERT ANGELOCH: Etchings and Blockprints from 1983 to 1988 with Introduction by Jean Wrolsen
1990	ROBERT ANGELOCH: Paintings and Prints 1988-1990
1990	*RICHARD McDANIEL: Catskill Mountain Drawings Introduction by Thomas E. Nelson

*Distributed by Purple Mountain Press

Purple Mountain Press Publications

1978　A CATSKILL SONGBOOK by Norman Cazden
1984　THE SLOOPS OF THE HUDSON by William E. Verplanck and Moses W. Collyer with an Introduction by Pete Seeger
1985　THE LAST OF THE HANDMADE DAMS: THE STORY OF THE ASHOKAN RESERVOIR by Bob Steuding
1986　THE RIP VAN WINKLE TOUR GUIDE by Arthur G. Adams
1987　THE LEGENDS OF THE SHAWANGUNK by Philip H. Smith with an Introduction by Alf Evers and Foreword by Carl Carmer
1987　TWO STONES FOR EVERY DIRT: THE STORY OF DELAWARE COUNTY, NEW YORK by Douglas DeNatale
1988　THE CATSKILLS: A GUIDE TO THE MOUNTAINS AND NEARBY VALLEYS by Arthur G. Adams
1988　THE HUDSON 100 YEARS AGO by Skip Whitson
1988　A CATSKILL WOODSMAN: MIKE TODD'S STORY by Norman Studer
1989　A TOUR OF THE MOHAWK, THE SUSQUEHANNA, AND THE DELAWARE IN 1769 by Richard Smith
1989　THE DELAWARE & NORTHERN AND THE TOWNS IT SERVED by Gertrude Fitch Horton
1989　TO THE MOUNTAINS BY RAIL by Manville Wakefield
1990　A CATSKILL KITCHEN by Evelyn Fairbairn Budd
1990　NORTH COUNTRY ALMANAC by Robert F. Hall
1990　A CATSKILL MOUNTAIN JOURNAL by Bob Steuding

Purple Mountain Press, Ltd. is a publishing company committed to producing the best original books of regional interest as well as bringing back into print significant older works. In 1990 Purple Mountain Press acquired Harbor Hill Books, a publisher of Adirondack, Hudson Valley and Western New York titles. For a complete list write: Purple Mountain Press, Ltd., P.O. Box E-3, Fleischmanns, NY 12430 or call 1-800-325-2665.

Nature is loved by what is best in us.
— Ralph Waldo Emerson

About the Artist

Richard Webb McDaniel (b. 1948, Berkeley, California) received the Master of Fine Arts degree in painting from the University of Notre Dame. Previous study includes California State University and the Art Students League of New York. He has taught drawing and painting at Connecticut State University, Post College, and for the past eight years, at the Woodstock School of Art, where he also serves on the Board of Directors.

McDaniel's paintings and drawings have been exhibited in museums, galleries, and colleges throughout the United States, and his works are included in prominent collections. He is represented by Vorpal Galleries in New York City.

McDaniel lives with his wife in a pre-Revolutionary stone house on 35 wooded acres, just outside Catskill Park.